PRAISE

M000050174

"Glowing, shattering poetry about blood and being blue-hooded and glistening as Woman, Whore, Slut, God-Seeking Catholic Girl seeking home. Love. Also autonomy. Agency. She's the one always being spoken of, and should be. Suarez rewrites scripture summoning the sweet strength of survival, having learned power through yielding to it. Visceral. Opalescent."

JENNY FORRESTER, AUTHOR OF NARROW RIVER, WIDE SKY: A MEMOIR

"Anna takes you on a journey from sensuality to despair and from hope to harsh realism. She captures the peril of intimacy through shattered rose colored glasses and takes you back to potential and most importantly, to awe"

GARRETT COOK, AUTHOR OF A GOD OF HUNGRY WALLS

PAPI DOESN'T LOVE ME NO MORE

ANNA SUAREZ

clash
BOOKS

Copyright © 2019 by Anna Suarez

ISBN: 978-1-944866-39-6

Cover art by Kerri Ciullo

Instagram, @botanicalbunny

CLASH Books

clashbooks.com

All rights reserved.

No part of this book may be reproduced in any form or by any electronic or mechanical means, including information storage and retrieval systems, without written permission from the author, except for the use of brief quotations in a book review.

*For my Grandma Connie
who showed me my love for poetry
before I knew I had it...*

And all the women of my life

Last night I wept. I wept because the process by which I have become a woman was painful. I wept because I was no longer a child with a child's blind faith. I wept because my eyes were opened to reality..."

ANAIS NIN

CONTENTS

OKCUPID

Slut
Is a word,

A slut loves her blowjobs,
Her liquor, her body, her
Freedom.

A slut stays out
in the wild night,
Blow kisses across the street
When her bus arrives.

She is always
The one spoken of.

But *her* words, the possible
hedonist erotic ecstasy or
unarmed, enmeshed, em-
battled sorrow, her truths,
unsung songs, buried

beneath a bed of
lilacs, nights

spent reapplying lipstick,
hovering over tumblers of water,
mugs of tea, glasses of wine,
A canvas sail drifting between
sentences, finding lost socks
under beds, putting earrings
back in my purse because I
couldn't find the back.
(he never looked, anyhow.)

Now my tea comes. The aroma
glides across my pours: herbs,
flowers, honey. Black
eyes watching my little sips, done
in fear of smudging red-velvet
lipstick, wondering if only
Living could be

herbs, flowers, honey.

I spread my legs during the first
ten minutes of 'Lost in Translation;'
Scarlett Johansson telling Bill Murray:
"I'm stuck," & I'm wiping salt slivers
of ocean from my cheeks as he
hold my hips beneath the
wave

WHITE EYELET

As I see I've spilled
huckleberry jam on
white eyelet, you take
my thigh, sink your teeth
into my flesh.

I know of the tulips in your yard,
Your hand-rolled French cigarettes.

Dr. Ramos says
"manic depressive"
and purses her lips
before her
transition
into the bill
I didn't pay.

I watch cars go by,
inhaling deeply,
lungs swollen to

the size of birds
because I want
to breathe this
entire city
in.

There are strands
of my hair, & drops
of perfume oil in
your bed.

I tell myself I am strands
of black hair, rose oil, in
a kingdom where castles
are hewn of raindrops,
patiently expecting
the Great Flood.

I WANTED TO BELIEVE IN SCIENCE
UNTIL I MET YOU

You speak of miracles,

divinity.

A luminous moon
and the azaleas that lead me
to your door: 234.

eating radishes,
heirloom tomatoes,
your lips grow purple,
the inside of a plum.

No.

it does not suffice
to see
the reflection of
clashing bodies in
the mirror,

all I want is
to feel your
entrance,
essence
of rain,
apricot, and saffron tea
down
my throat.

Touches &,
caresses.
swimming in a
lake &
swimming
in an ocean,
waves & rifts.
you,
a rise of phantom waves,
root to crown.

I tiptoed across
rocks in a quiet creek,
grasping
human experience
watch light trace
peach blankets at dawn,
as *you* trace my calves
with your feet,

your lips, "divinity."

What are miracles, my
visions of angels, only to find
airplanes taking strangers

to holier lands,

What is science
when there isn't
any other way to describe
caresses as phantom waves,

never fleeting.

Dawn will rise, the grass will
produce dew, the moths will
wither in the light,
but divinity/human experience
is felt in
waves and caresses.

IT HURTS TO LOVE A MAN

yeast infections,
they stink.

it hurts
but I'll wear
my underwear
when I sleep.

I am such
a stranger
in my
sorrow
when
you leave

door shut——
what now?

write poetry.

phone shining
in the low light,
I let the other
shine,

his shiny
collection of
others.

my pain
he refers
to-

"you are
not like
the others"

BLIND FAITH

Rebirth is loud on city streets.
In the language of love and daffodils,
You take in the scent of my thigh,
And I'm not shy tonight,

So I look at you.

I walk home
Before the air chills,
Count the azaleas
On the trees

And cry.

Last night I associated your presence
with morning rain and bluejays, then
pulled the red sheets over my head,
melted into satin

monde rouge.

What if I whispered to you Fear
rather than Joy, what if I chose
Montmartre and Marseilles over
Le désir de minuit: Breath/Breath,
Hands/hands, behind a lace curtain.

Tenderness has always smelled
of fear & spring dew. Intimacy is
the flutter inside the knees,
drops of rain on goosebumps,
Somewhere beyond the tumult,
The grandiose waves of
Indecisiveness & dreams.
I want you, somewhere beyond
my eyes closing with your weight,

I want you.

GRANDMA

Grandma accepted her fate. Stretched across the red couch, she blew smoke in our faces.

When they kill me, I will be with my husband again.

Mom visited her in heaven and found her floating in a ballroom with her pilot. Life isn't worth throwing away your cigarettes, dumping your wine, drifting in dreams alone...

I keep her ashes in my closet. I grasp the bag every once in a while, imagine how my ashes would dissolve in the sea. I regret the scarf breaking on the hook as I collapse on the kitchen floor.

As I fall, I notice the tomato sauce stain on the tile.

If I give up my body to the sea, the salt water will cleanse my sins. Sea foam will birth a new form, perhaps formless.

Ocean drowns adultery before a body hits its surface and I fall like petals lost in a fragrant wind.

If only a small hook, could accept my fate and send me to Elysium of the drowned. If only a blade turns my blood into fairy dust. Queen Mab touches my hair.

Julia says I am of the drowned.

In death, I do not fall into loneliness.

When you fail at killing yourself, a part of you is still dead.

Sugar daddies weep to weaken the flames. I drop belladonna on their wounds.

But on the floor, I am released from my dreams and clean the sauce stain off the floor.

SWOLLEN MOUTH/HOLY WOMB

my vulva?
a wet ache.
sculpted in
amber triangles
painted
on cave walls.

where do I
find longing
in a river?

wailing— my breasts collect sweat,
my bangs furl
in a lecture hall.

men ponder the ethics
of abortion.

and what became of my body?

as shame looks me in my eyes
whispering he likes me
with my hands up, with a
smile across my face.

on his marriage bed—
deception.

desire collects red
fruit juice in
a white ceramic
bowl.

oh, to tell you I exchanged
my school girl outfit for
black lace, nylons, and red nails
to feel more like a woman...

the immeasurable
weight of flesh
underneath a mahogany
Italian crucifix.

to give birth.

to replace vitality,
one full
merlot mouth
with stillness.

and... ghouls wail for their
mothers behind my door.

I barricade myself

with scripture
with sea salt
with coagulated blood.

full moon with the father
cast out into
a field
of wild rose.

suspended
beside a priest.

painting my face
with ash.

washing my feet.

an ivory fountain.

i must have miscounted
my bones...

PAPI DOESN'T LOVE ME NO MORE

expanded
outstretched
along the river
waiting for God,
waiting for *you*.

summoning water lilies,
caressing the hem
of Heaven's skirt.

one last note
on the mirror-
ne me quitte pas...

I am sorry for the
dust that collected
like pollen
on the books
I never read,
the sound of guilt,

my shame
keeping you from sleep.

One last morning-
one last touch-
the soft light

illuminates our pocket
of lunacy.

you're standing
beside the bed-
hard
and I reach you
across mountains
let the desire
exonerate the pain.

the weight
of your hand-
the weight
of a lack
a laugh escaping
from all I have left-
all I can do.

how I would give it
give it all away
for touch

any kind of touch.

Holy, holy, holy,
the rhythm of the smoke

escaping from your lips,
conquer the space
with all the
words I could
never verbalize,

the only piece
of me inside-

an empty laugh.

what do I take back?

the roses

of your apologies
the relief
from every small
sip of tenderness,
perhaps a saffron cookie
from the
palm of your hand.

the hands I begged for-
adored, feared
with all their
sweetness
and violence.

in the river
salt sterilizes
the impression
of the psalm
on your fingers.

I don't want to
stay in this river
I don't want to
touch the shore
or touch the bottom.

oh, if only I could
sink here
never
experience a world
where you are gone
and still
look me in the eyes.

As I sink further
to the bottom-

I discover the
sunken city
the Atlantis.

There is the staircase
From Sagrada Familia-
with all my sorrow
and my words:

this is my Sisyphus.
walking up these stairs
and never finding you.

beside the stairs
there is our bed,
the notebooks
you have thrown

at me,
the roses,
the sculpture of
your hands

Then I find
my own little hands-

and I swim away.

SALOME

I see myself in young women. Lonely, tired eyes… dejected.
They wear the tight black dresses. Pray they are paid.

I need to make the electric bill this month, fuck.

I imagine candles lighting the room on the windowsill like
altars. The coconut oil next to our bed dwindles.

I do not want to live this life- stranded deep at sea, trying
to cleanse the remnants of your betrayal.

Did you shower before you made love to me? Did you kiss me at
3am when you said you would be home at midnight?

I want to come home. Perform a ritual while the moon's
bloody harvest rains all over me, sleeping on the altar you
built. I will be sleeping under the willow tree, the lilacs.
Then burn the money that belongs to my darkest self.

I want to come home…

They say to move gently forward. They say cheating is in your bones- in your veins.

Give me directions to the realm where women are not disposable. Where the wine is in a fountain. Where scriptures are written in menstrual blood.

A place where…. My mouth does not quiver.

A place without sugar daddies, where I don't need them.

A place where….

I quiver.

A place where my love is golden and sweet. Where it's enough.

DAYDREAMS

somewhere in between
the concrete
the ice,

I bathe in
the moonlight,
holy
opalescence.

adultery purifies
in holy water.
thoughts-
quiet.

see your head
rise from
depths.

we are quiet.

there is no one else
nothing else.

no misogyny
on the radio
as I lie
on the couch
pretending
to sleep
tears fall,
remembrance-
shame.

listen to my pain.

sometimes
I just
need
out.

SISTER

Two sisters:
one is not
good enough.

I didn't need to have another baby,
But I still had you
And you were my little sweet pea.

Mom birthed
one boy, one girl
colorful
symmetry.

I followed
stayed quiet,
listened to
the ghosts hum
like saints
in my closet.

Girls learn defeat
before they learn
love.

Girls learn to see
themselves in
opposition.

Who
blesses the tree
with the most fruit
for the elders
to pick,

to package.

I hurt when I reach
and the shelves fall,
shattering glass.

Sister says I touch
and I destroy,

I move across seas
and destroy
quietly.

PREPARATION

I wasn't prepared
To know
I can be raped:
1
2
3
4 times
by a person I love,
by a person I didn't love.

What happened to me?
as I walk
alone in the rain.

Dripping, lifeless,
barren body.

taken.

demands of:
blood, marrow, bone.

The aggressor
smells of love,
shares my bed.

My mom warned me
of aggressors,
they take girls
from sidewalks,

but I built
my grave
in his tulip patch.

I will give it
give it all
give it up

for love.

what I have done...

he pulls out my tampon
pulls my innards
with his thrusts,

The weight of
cotton & blood
hitting the floor.

my reflection in

the fruitful crop, nourishing bellies,
Witch hunters
splattered blood
upon my leaves

and spread my pelvic wings

PEARL

Do you think I'm sexy? He writes on the envelope of cash.

We are sitting in Starbucks, writing notes to each other. Half lies and half desires. He tells me he has a proclivity for women in red nail polish with dark hair. My cherry painted nails stroke the straw of my drink. *Pay attention. No bathroom breaks.*

I feel unfamiliar in my skin, between sips, I wonder who the woman is in the cherry nails and the leather jacket. *How is she so good at telling lies?* The little girl inside me is ashamed that after two decades of dreams, this is where I am, writing notes on an envelope stuffed with hundred dollar bills.

Weeks later, I meet a man with dark hair, kind eyes, and a short stature. He tells me to meet him at Le Pigeon for dinner. He orders us the chef's six-course meal: foie gras, decadent red meat dripping into lush veggies, and two bottles of wine.

He is the kind of man you know will fuck you up, even if it is business.

Two hundred dollars in an envelope for dinner. For drinking until I believe my own lies.

Months later, I am at his house high on the hills. I have not spoken to him in a couple months because I wanted to know if someone could love me in ways that did not include a white envelope at the end of the night, a monthly allowance, my body as a palette for their high culture fantasies. I fell in love. The money wasn't worth it… until I ran out of money.

Three cocktails and one empty stomach later, in the solitude of the west hills, he takes me to his bedroom. There was no question, only his gentleman's hand as an invitation. Maybe it is the Tanqueray, but I feel nothing. I accept his hand and stumble up the spiral staircase.

Whores can't be raped, they say.

I leave my earrings on his nightstand, they glisten in the low light, and their faux gold mark my presence. Unrefined.

The little pieces of me are what fucked it all up.

He takes me on a bed that holds no love in its crisp white linen. I close my eyes. I waited until he turned me around to cry. I did not know this until my friend tells me about our phone call.

Maybe it was the Tanqueray.

He messages me: *You left your earrings. I will save them for you.*

I scrub away my guilt and my shame in the shower. The particles embedded themselves deep in my skin. I can feel myself unclean. The sweet defeat, I fall into my bed. My bed I haven't washed to inhale the smell of love. In the darkness, under the covers, there is no reveal of myself, only the scent of home. I do not want to see myself.

His wife finds the earrings and I live my life in fear. The fear the police will show up at my door, the fear I cannot separate exchange from love, the fear I am only worth a white envelope.

The fear I did this to myself.

I chose to rape. I didn't learn my lesson.

I broke a home with a pair of white earrings. I shattered a woman's confidence. I have known pain like hers.

I find myself longing for innocence, clinging to desire for virginity.

When September arrives and the air of impermanence casts its light, I recognize the arrival of my womanhood. All of the shame in my pain that I cannot shed. The fear that all will be taken at the hand of one man, or one pair of earrings.

SUGAR/A RITUAL

give him sugar:
hair removal, angel
smiles, chiffon
innocence.

the oyster in
the mouth,
bitter salt.
tongue-
the sugar.

the earrings
left on
the nightstand,
clumps of
white sugar,

deadly sweetness.

refined sugar

embedded in flesh
smelling so sweet
until the exterior rots.

exfoliate with sugar-
tearing perfumed skin,
notes of cologne.
reveal the bone,
muscle, vein.

scrub away the
exchange, scars,
punishment,
the sweet identity.

sink, sink
in deep blue.
Gods sprinkle
ambrosia on
your lashes,

fall to the
ocean floor,
sand replaces
sugar.

our demise
is not to drown,
but to rise
when rosy
fingers of dawn
reveal what
we have done-

the sugary
skin glowing
in the light-
dawn & land is
our threat.

A BREATH OF TEMPORALITY

saltwater filling the drain,
the clotting of disassociated ash.

falling to the floor
a single breath
psalm
engraved with menses.

Guide me to the river
where you feed,
two breaths

one breath.

Across the bridge,
mirage
of sirens,
seductive in
the Willamette.

sweet temporality-
the touch,
inhale flesh
the destruction-

pelvis to pelvis.

refuge from bitter silence
with the absence
of a telephone ringing.

God sent me his angels
to the Valley of Grey.

the heart beats too loudly,
the pillow is too stained,
florid wilting petals.

Nightmare/ecstasy
blade drawn,
a plea for a glide of

April rain,
for belly aches and
sucking dick,

for the zealous weight
of *another*
beating heart

EMBODIED

kneeling
before him,
bridges
in my brain-

St. Johns?
Ross Island?

June
& on
suicide watch-
the water is
warm,
the highway
aligned with roses.

rose colored
pills in the
cabinet, his
pocket knife

in the night tab-

cock
deep in my throat…

take it in,
grasp his
shaking legs.

Suddenly,

I am saved.

condensation
of loneliness
humid, misting
longing

peonies kissing
his biceps,
his fantasy-
to see me smile

him
him
him
and him
love
when I smile,
my head
slamming
into the headboard.

fuck all the pills,

I only need you.

my body
underside
of pale sage
your body,
voracious stems
unchanged, never
wilting.

I wear
your clothes,

smile.

my body is not mine
my body is not mine.

an exchange
for the virgin whore
lips, fingers,
hips,
baptized in

the money—
she is virginal,

(dis)possessed.

I gave it all away
then I took it back
and you took
back what
you could.

saw myself
submerged,
nothing to cover
the breasts, the
pubic triangle.

so fuck your
money
keep your
big cock,
keep my
flesh
my bones
drink
my blood
drain me

my body is mine
my body is mine

I may fall at
your feet
in pieces

glistening
shards of
guilt
and fear

though,

you will not mend me.

who cares if

you cease to see
your reflection
in my artificial
totality.

If I remain
glass shards
on mahogany
or swollen,
blue, watery
lungs
under the bridge,

my body is mine

my body is mine.

SHATTER AND FLOW

Hands made of glass
they shatter on your skin-
leaving imprints...

we bleed.

How can I stop
the flow of blood?

I never learned.

Lying on the stained sectional-

disembodied.
crumbs on the floor-
shattered glass.

My mother's face
as I lie
languid.

Her dramatic mascara,
hot rollers,
dried tears- deep under,

some of us
dry
our tears
before they

fall.

I never learned.

There is woman
at the grocery store
on all fours
dressed in black,

I never learned.

Mom,
I am sorry.

I regret
so
much.

*"your father failed you,
remember the years...
all the years
he forgot you?"*

I try not to.

he told me that
drinking coffee &
ice
water
shatters
your teeth

The growing pains
of childhood,
farmhouse to
farmhouse.

The cherry blossoms
so fragrant
with the sewage-
pungent.

It wasn't enough,

I am sorry.

The cherry blossoms
they fall to pieces
ash-
Grandma in the urn.

I walk across the
Charles Bridge
in her memory,
Grandma.

Your voice-

"you never stop loving

the father of your children."

Do I love———

empty?

I think I am broken.

In the realm of woman,
I know
you did your best.

There were the men-
they positioned you
suspended in

motion,

placing
the mirror
in your hand
told you
just to look
in their
eye.

there were men
who taught me
a bowl of soup
is not-
it's never
enough.

taught me

never look in
the mirror,

there are women,
other women,
always other women.

I am still other woman,

Maybe I should have
bought the black slacks…

no, it wasn't worth it.

I lied about
being drugged
in Barcelona.

*"you just didn't want to answer
my call."*

my pain
dulls my
love's
lightness.

pray:

*"please
stay the same."*

absolve:

"I'll pour you soup."

ocean too dark
to see the surface.

Fill me with your fire
Fill me with all you
have.

there is half of me
suspended
in
motion

waiting for my
clumsiness
to shatter

all my love.

I'll start growing breasts
filling voids
with the bodies
of all the others.

all of them

only to shrink.

"Let go...."

I will not
stop
trying.

Though,

I never learned

until I
bled
and did not
stop-

wet.

NARCISSUS FLOWER

I moved to Oregon for its lushness, the moss dripping from the wet rocks like teardrops. There are golden glazed mysteries in the high deserts, the wind tunnels on the coast, forests that stay green all year, all the mixed terrain.

The city streets are different. Mysteries stay mysteries and yet, I am too visible, succumbing to mysteries of my self-hood based on my visibility to others.

I am waiting outside my dorm for the cab my first client called me. I ask myself, *"How did I get here? Do I need the money?"* I am helpless in my quest to know I am worth something, even if it's just a pile of cash.

The stars gleam above the buildings and I feel the ache to communicate with God, to see myself in the moonlight with no skin, no breasts, no bone. Just for a moment.

My ex boyfriend told me: *"You seem so seductive and self-*

assured, but truly, you are still that little Catholic girl, searching for God."

It is true. There are certain fabrics on my body that are silky, velvet, and shining. In the stars, they shine too bright. I wish I did not have a body to ornament. To sell. The narcissus flowers in my hands glisten in the glass of puddles under my feet and I see myself. A plea: *I am not made for this world, I was stolen and trapped.*

An extraterrestrial, too much and too little for humanity. A narcissist.

There is fear of my frailty, how I must question *being* and ethics. I am a bad person.

A person.

One man depended on lunar cycles, menstrual blood, and presupposed frailty to create woman. Linguistically, the temporal body birthed in silk or sea foam assumed itself as a womb, nothing else. If only we could see ourselves beyond our bodies. Beyond our mysteries. Beyond the strive to know.

Frailty is what I sell. My legs unfold like doves later that night in one feathery collapse. I yield as he persists. I want to have strong bones and power, but this what I chose. *But why?*

I'll walk in the wilderness again and forget about language, honor a time so ancient there were no bodies, the wispy canopies of trees cradling little balls of light. There are no mistakes, no regret, no guilt. Before mysteries.

HONEY

if only I could refill my lachrymatory
with your honey,

pour it inside me.

what I had left evaporated

when I waited in the airport
hoping you would

come back.

Carry with me
(with you)
a heartbeat, a heartbeat
birthed in merging of our internal seas:

one aquatic meridian.

a heartbeat escaped me,

our heartbeat escaped me.

bloody toilet water
fleshy petals,

I said nothing.

just watched you play video games.

January
and all the Sycamore maples
are barren.

I talk to myself a lot.
I touch myself a lot

in your memory,

at night and watch my honey
glisten in me-
hidden under thick black wool.

honey collects in the crevice of my fingernail.

spread the honey
the love…
what I have left of it all.

I take the honey into my dreams,

walking to the altar and fall,

honey on my lips,
I surrender

it all, let the south winds
carry it all the way to the South Pacific

wherever you may be…

mornings are the hardest,
I have to be brave.

so I drizzle honey on my oatmeal
watch the blueberries glisten in
the light-

all their light.

in the light
for just one moment-

you will come home.

CATANIA

We move to the private suite
on that morning you split me in two
like a pomegranate
spilling its seeds and sweet and tart
juice
on the bed sheets,
growing bitter
while our bodies

merging.

I kiss you
at the temple of Hera,
in a space
no one else
has ever
had you,

distorting the

obsession
masochism
of all the beauties
you caressed
horizontally
across the South Pacific.

I tell you
I prefer
Mediterranean air
fighting battles
against hot
milky white
caramel
dulce
espresso,

The sun and the breeze
The sun and the breeze
The sun and the breeze
(repeat,
repeat)

please

put me to rest.

you are so powerful.

The hairs on your legs
(hairs on your legs
hairs on your legs)
painted gold--

the long
fields of wheat
wrapped
around slender
highways.

At the inlet
curled amongst
the volcanic rock,
you tell me
you will rise

please.

counting
pages,

wait

to see your head
at the surface, and

open for you
open like the
wildflowers
that hold our
feet steady
on Mount Etna

open for you...

preserve all your citrus,
all your sweat and

bottle sea water,

why did you leave?

Stay

in me
at hotel Cecil,
end Italy's
4 month drought
with our rain,
our sweet water,
the streets as wet
as our bedsheets.

wait

for me to
spread my lips, tongue
in all the crevices of your
chiaroscuro,
only to drown

in the bitterness of the wine,
in the sweetness of the apricot,
the fragrance of rose water, the
sweet water,
tartness of pomegranate.

melting
creamy gelato
simultaneously
heavy obsidian,
sinking deep

into the depths
where you

wait

where you

stay.

LOYALTY

nightmares
of the tears clogging
my throat.

You left so easily.
I waited in the airport,
every hour--
Maybe he will come back.

couldn't swallow
for days.

You can fuck,
erase my loving
hands, deep sleep,
the difference
between us,

Drain my vitality,
distort my reflection,

graceless and foreign.

swollen rose mouth,
be quiet. the messages
on your phone, lightness
of the muses,
I drain my own
vitality.

Men will tell every woman
her body is a work of art---
As long as she is languid.

I bleed off canvas, droplets
spilled across the table,
pigmented, too fast.
too slow.

hearth overflowing

gentle meows,
fragrant steam.
What I have built:
no home, a lack
no reason to return
to my questions,

no explanation,
broken lies.

It is not worth it
to love travelers who
watch me wither
out of temporal

wholeness,

shrinking, lunar
& waiting
expanding.

Tide too high
for you to swim.

just tell me
about women,
the beautiful women
accents, skin, height,
blond, opposing:

you could have had them all.
(The lock clicks,
my vitality in his pocket.)

But he chose you.

SEA GLASS

Bali's tidal waves pull me away from sanity, skin weathered and frosted like sea glass. Your lies circulate like grains of salt and round my sharp edges; my body succumbs to the defeat.

In Bali, the air tasted sweeter. There was more adventure. A woman becomes less of an adventure- a duty, a whimper, an unheard cry in the middle of the night.

The home she builds will not enchant like the moan of adventure.

I want to be a thing of beauty a traveler collects from the shore. I want to be the moonlight at sea that illuminates truth.

I must change form in the sea.

I hope you feel the softness of the petals on your skin, how

they wither in light. How they wither with too many touches.

In the darkest hour, I remember how I imagined a ball of light at the end of every sea, but with womanhood, I only saw darkness.

Waves arrive at our feet in all shades of blue: you arrive at the lightest seas and you fear depth. I will take you to my darkness. My darkness hates time, how the end seems too close.
I want caresses to restart. To stay. To circulate against the ends.

All women wear blue robes, have seven daggers in their hearts, whatever they may be...

My seventh dagger is that I am not a feminist. It is that I need you.

MAGNOLIAS

Magnolia flowers
blossom before
their leaves.

Petals yield,
a whole
falls to pieces
for a one---

one touch,
one windy exhale,
one cold night.

Pieces of
pink, flesh,
matter,
shrivel --
driveway
home.

Where do you go
if no one else
builds your
home?

under white moon:
brown nipple,
tickle of cotton,
too delicate
for the many
caresses-

one strong hand,
fall to pieces.

they should have told you
the body weakens over time,
we blossom before the
rest of the tree &
those brought to
life in pieces
must break.

MELUSINE

There is no man to love here,
no womb to fill.

In between
sea and land,
abuse and love,
mom told me

to plunge.
we were born
sirens prone to
seafoam
demise.

my robes fall
to the rocks,
sea salt: a call
to nature's limbo.

blue robes

whisk away
like angels
and the moon
shines on
my feet
plunging into
the sea as

one part fish,
one part warm
blood.

A kind hearted man may bring us to grass, meadow, wood,

we can give ourselves away: warm blood,

warm devotion.

or our bodies disintegrate to sea foam.

woman must plunge...

the inevitable risk.

ACCIDENTS HAPPEN

The way you say

you still love me.

Your tone empoisons the living room with smoke as the gin in my belly boils. I am losing the smoothness in my touch. How am I to shrivel in my words in the static of a phone call: It happened again and I am weak.

You were in the jungle.

In the lilac bed, I call forth my guides: God's hands will punish with angels by my side, whispering my rapist. That in the kingdom of Heaven, Naomi will stand before me. All of the holy women will raise their hands and the stardust will twinkle in our hair.

I hope my tomb is erected in blushy tones of marble. There can be a raised death bed of roses and silk. I was a silk-worm and died. I built my own bed.

Before I died a man, disguised, he led me up a stairwell

he poisoned me, I was asleep.

In the morning I showered and hope that it didn't happen, yet again.

Accidents happen.

I evaporated when you took her into your arms by accident. When you told me it was just a kiss. When you told me I could not be replaced.

When you told me I fucked the devil.

In your eyes, whores cannot be raped, it is merely, one deliberate accident.

Two lies- you & me. Two accidents.

PALETTES THROUGH TIME

Rose. The labia pulsating hope that Eros outlives Jehovah . The fingers so rosy with the coming dawn tracing circles around all of the bodies' corridors underneath the comforter: winter's romantic interior. Everything would turn rose under the comforter in the soft light. There is nothing to see in these moments, just feel eternality in the fingertips. I taste the sweet impressions of reverence that exist between permanence and impermanence.

Gold. The golden flames breaking through midnight across the faces of sinners, which I find to be old friends, old lovers, memories of colors, and touches. The priest utters "let there be light" with his fingers returning us to Him. Immersed in the priests holiness and the decadence of the Catholic Church, I prayed that my knees would never grow too weak for me to kneel. I would pray my soul would never be too weak to surrender. Then you ask why I wish to remain on my knees. I whisper in your ear, *"that is because I love you."*

. . .

Ivory. Visions of the Christmas I drove through the sprawl with an ex lover, the twinkling of the lights on the houses and the opalescence of the moon all shining in their temporality, then fading into the grey shades at Airport Security. *To be so young and convinced families would leave their christmas lights up all year. That Spring would never come. That birds never truly know a home.*

Blue. The color of the sky right after sunset. Winter told me to keep fighting for you and that you will be home soon. In between grey I found bright blues, lighting up the cold bedroom with hope. There was a church choir lamenting past the blue skies into the heavens, *"come home, come to the light,"* and I persisted.

ACKNOWLEDGMENTS

Thank you to Leza Cantoral and Christoph Paul of CLASH Books for believing in me as a young writer and empowering my work.

Thank you Julia Laxer for sitting with me in cafes for hours as we furiously typed and drank cans of wine. Your guidance has made this book possible.

Thank you Garrett Cook for working with me for many years and supporting my growth as a writer.

Thank you to my mother for always standing by my side. You are my number one supporter. I would not have been able to write this book without you.

ABOUT THE AUTHOR

Anna Suarez is a queer Cuban American poet and story-teller. She started her writing career by doing open mics at local Portland bars. Her publications include stories in Exotic Magazine, poetry in Unchaste Volume 2, and schol-arly research in *Comparative Woman.* She holds a Bachelor's degree in Philosophy and French from Portland State University.

ALSO BY CLASH BOOKS

TRAGEDY QUEENS: STORIES INSPIRED BY LANA DEL REY & SYLVIA PLATH

Edited by Leza Cantoral

GIRL LIKE A BOMB

Autumn Christian

CENOTE CITY

Monique Quintana

99 POEMS TO CURE WHATEVER'S WRONG WITH YOU OR CREATE THE PROBLEMS YOU NEED

Sam Pink

THIS BOOK IS BROUGHT TO YOU BY MY STUDENT LOANS

Megan J. Kaleita

ARSENAL/SIN DOCUMENTOS

Francesco Levato

THIS IS A HORROR BOOK

Charles Austin Muir

I'M FROM NOWHERE

Lindsay Lerman

HEAVEN IS A PHOTOGRAPH

Christine Sloan Stoddard

Christoph Paul & Mandy De Sandra

GODLESS HEATHENS: CONVERSATIONS WITH ATHEISTS

Edited by Andrew J. Rausch

DARK MOONS RISING IN A STARLESS NIGHT

Mame Bougouma Diene

GODDAMN KILLING MACHINES

David Agranoff

NOHO GLOAMING & THE CURIOUS CODA OF ANTHONY SANTOS

Daniel Knauf (Creator of HBO's Carnivàle)

IF YOU DIED TOMORROW I WOULD EAT YOUR CORPSE

Wrath James White

THE ANARCHIST KOSHER COOKBOOK

Maxwell Bauman

HORROR FILM POEMS

Poetry by Christoph Paul & Art by Joel Amat Güell

NIGHTMARES IN ECSTASY

Brendan Vidito

THE VERY INEFFECTIVE HAUNTED HOUSE

Jeff Burk

ZOMBIE PUNKS FUCK OFF

Edited by Sam Richard